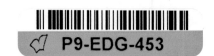

Indian Summer

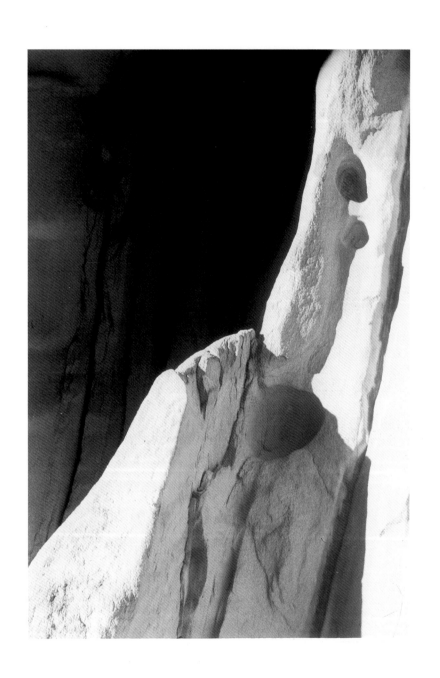

Indian Summer

A NATIVE AMERICAN VIEW OF NATURE

BETSY WYCKOFF

STATION HILL ARTS
BARRYTOWN, LTD.

Published by Station Hill Arts/Barrytown Ltd., Barrytown, New York 12507.
Station Hill Arts is a project of the Institute for Publishing Arts, Inc., a not-for-profit, tax-exempt organization, supported in part by grants from the National Endowment for the Arts, a federal agency in Washington, D.C., and the New York State Council on the Arts.

Library of Congress Cataloging-in-Publication Data
Wyckoff, Betsy.
 Indian summer : a Native American view of nature/Betsy Wyckoff.
 p. cm.
 ISBN 1-8869449-05-8
 1. Indian philosophy—North America. 2. Philosophy of
 nature. 3. Landscape—United States—Pictorial works.
 4. United States—Pictorial works. I. Title.
 E98.P5W93 1995
 113'.089'97—dc20
 95-8604
 CIP

Cover and book design by Betsy Wyckoff.
Cover photo: Sandstone abstract.
Copyedited by Robert Weber and Joyce Portnoy.
Printed in Hong Kong.

Definition on page v: Used by permission. From Merriam-Webster's
Collegiate® Dictionary, Tenth Edition ©1994 by Merriam-Webster Inc.

Indian summer *n* **2:** a happy or flourishing period occurring toward the end of something.

Merriam-Webster's Collegiate® Dictionary,
Tenth Edition

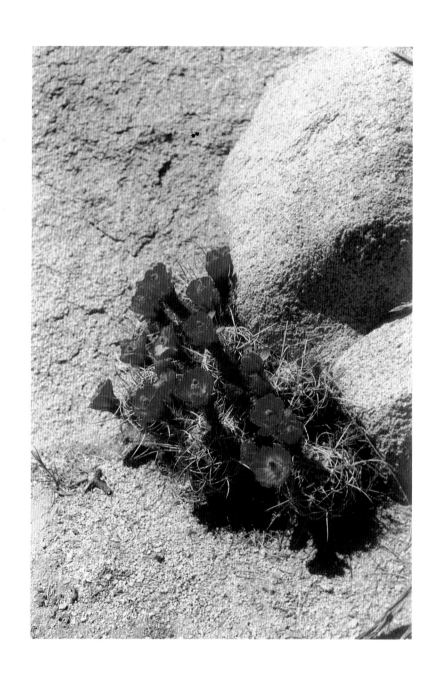

Contents

Preface *IX*

About the Authors *XI*

About the Photographer *XIV*

Ohiyesa *3*

Brave Buffalo *5*

Standing Bear *7*

Shooter *25*

Chased-by-Bears *33*

Zitkala-Ša *35*

Crowfoot *39*

Seattle *41*

List of Plates *47*

Acknowledgments *49*

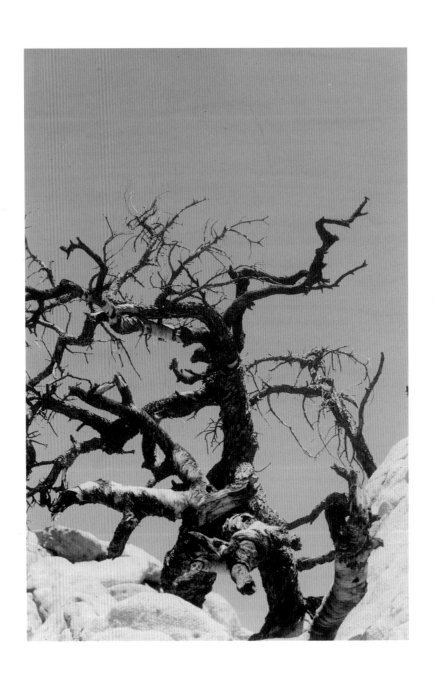

Preface

Aldo Leopold tells us, in *A Sand County Almanac*, "It is inconceivable to me that an ethical relation to land can exist without love, respect, and admiration for land and a high regard for its value." Most Americans have never experienced untamed nature. Our ancestors saw the wilderness as something to mold, if not to conquer. We have no history of living with nature as an equal.

Native Americans display a reverence for the land and its inhabitants. They believe that all elements of nature are related because all are children of the same Great Spirit. Nature, as an embodiment of the sacred, is to be revered, not desecrated. The Native Americans represented in this book may help us learn to love, respect, and admire a land we have long neglected. Through the wisdom of these ancient

peoples we may come to understand what John Muir meant when he said, "The clearest way into the Universe is through a forest wilderness."

BETSY WYCKOFF

New York, New York

About the Authors

Brave Buffalo, a prominent medicine man of the Standing Rock Reservation, was born in 1838 near the present site of Pollock, North Dakota. The excerpt reprinted here was recorded in 1911 when he was 73 years old. In this passage, Brave Buffalo describes his boyhood curiosity about the mysteries of nature.

Chased-by-Bears, a Santee-Yanktonai Sioux, was born in 1843. He took part in the Sun Dance and twice served as Leader of the Dancers. His comments about nature were expressed during a discussion of the Sun Dance ceremony.

Crowfoot was a well-known Blackfoot warrior and orator for the Blackfoot Confederacy. The Blackfeet were a nomadic people who inhabited the Great Plains from the Upper Missouri to the North Saskatchewan rivers. Crowfoot's last words, printed on page 39, were spoken on his deathbed in 1890.

Ohiyesa (Charles Alexander Eastman), the son of Chief Many Lightnings and Mary Nancy Eastman, was born in 1858. He fled with his grandmother and uncle from his Minnesota reservation to Canada during the Sioux Uprising of 1862. At the age of fifteen, he returned to his father's home in the Dakota Territory. Ohiyesa received a Bachelor of Science degree from Dartmouth in 1887 and a medical degree from Boston University in 1890. He worked as a physician at the Pine Ridge Agency for three years and wrote eleven books during his lifetime.

Seattle was chief of a tribe, known as the Dwamish, who lived in the Puget Sound area of the Washington Territory. He was born around 1790. His feelings about the land were expressed in a letter to President Franklin Pierce in 1854. This letter is reprinted on pages 41 to 44. Chief Seattle surrendered his land one year after writing to President Pierce, by signing the Port Elliott Treaty in 1855. As foreseen in his letter, Chief Seattle and his people were relocated to a reservation soon after signing the treaty. A monument was erected on his grave in 1890 by the people of the city named in his honor.

Shooter was a member of the Teton division of the Dakota (Sioux) tribe. His observations about nature were made in the early 1900s when he was living on the Standing Rock Reservation. Shooter was described as "a thoughtful man, well versed in the old customs."

Standing Bear was born in 1868 and was one of the first students to attend the Carlisle Indian School in Pennsylvania. After leaving Carlisle, he became a teacher at the Rosebud Sioux Reservation in South Dakota. In addition to teaching, he worked as an agency clerk, storekeeper, assistant minister, and rancher. He left the reservation in 1898 to join Buffalo Bill's Wild West Show. In his later life he became a lecturer and writer. Much of his writing is devoted to a description of the customs, traditions, and status of his fellow Native Americans.

Zitkala-Ša was born on the Yankton Reservation in South Dakota in 1876. Born as Gertrude Simmons to a Native American mother and a white father, she renamed herself Zitkala-Ša (Red Bird). She left the reservation when she was eight to study at White's Manual Institute in Wabash, Indiana. After White's, she attended Earlham College in Richmond, Indiana. From there she went on to study at the New England Conservatory of Music, where she became an accomplished violinist. She published two books in her lifetime: *Old Indian Legends* was published in 1901; and a collection of autobiographical essays, *American Indian Stories*, appeared in 1921. She married Raymond Bonnin in 1902 and moved to the Uintah and Ouray Reservation in Utah. After fourteen years on the reservation, she and her husband moved to Washington, D.C., when she became secretary of the Society of the American Indian. In 1926 she founded the National Council of American Indians.

About the Photographer

Betsy Wyckoff was a college textbook development editor for many years. More recently, she has devoted her time to writing and photography. The photographs in this book represent more than thirty years of photographing nature throughout the United States. Her photographs first appeared in a group show at the Sierra Club's New York office in the 1960s. Since then her work has been shown in numerous galleries and has been selected as cover and internal art in several publications. Her photographs are owned by a number of private collectors. Betsy Wyckoff lives in New York City.

Indian Summer

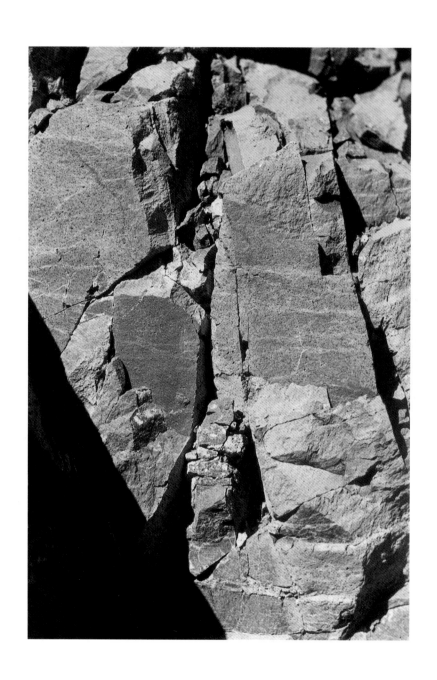

Ohiyesa

The elements and majestic forces in nature, Lightning, Wind, Water, Fire, and Frost, were regarded with awe as spiritual powers, but always secondary and intermediate in character. We believe that the spirit pervades all creation and that every creature possesses a soul in some degree, though not necessarily a soul conscious of itself. The tree, the waterfall, the grizzly bear, each is an embodied Force, and as such an object of reverence....

Whenever, in the course of the daily hunt, the red hunter comes upon a scene that is strikingly beautiful or sublime – a black thundercloud with the rainbow's glowing arch above the mountain; a white waterfall in the heart of a green gorge; a vast prairie tinged with the blood-red of sunset – he pauses for an instant in the attitude of worship.

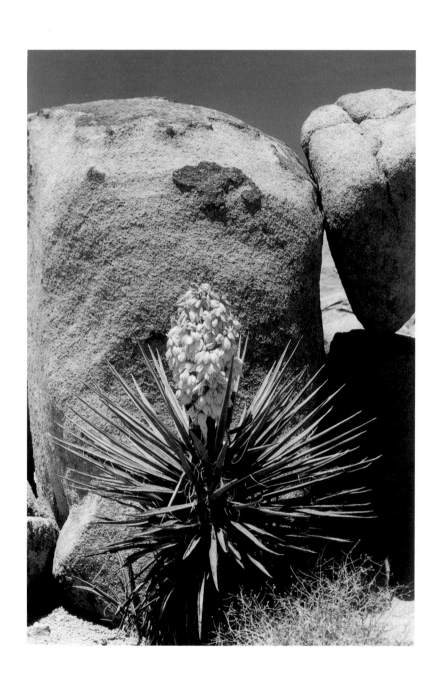

Brave Buffalo

When I was 10 years of age I looked at the land and the rivers, the sky above, and the animals around me and could not fail to realize that they were made by some great power. I was so anxious to understand this power that I questioned the trees and the bushes. It seemed as though the flowers were staring at me, and I wanted to ask them "Who made you?" I looked at the moss-covered stones; some of them seemed to have the features of a man, but they could not answer me. Then I had a dream, and in my dream one of these small round stones appeared to me and told me that the maker of all was Wakan Tanka, and that in order to honor him I must honor his works in nature.

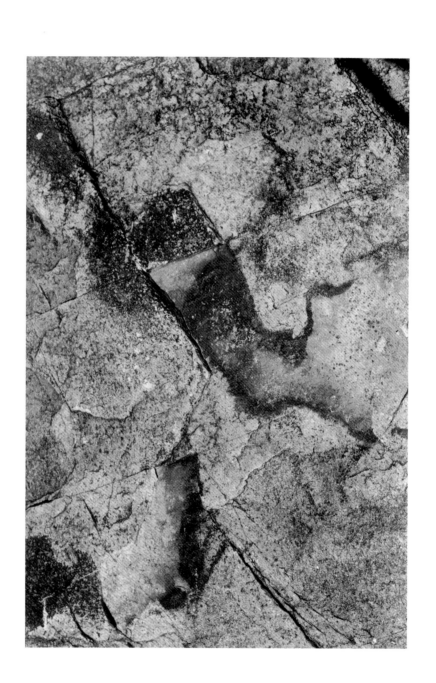

Standing Bear

The Lakota was a true naturist – a lover of Nature. He loved the earth and all things of the earth, the attachment growing with age. The old people came literally to love the soil and they sat or reclined on the ground with a feeling of being close to a mothering power. It was good for the skin to touch the earth and the old people liked to remove their moccasins and walk with bare feet on the sacred earth. Their tipis were built upon the earth and their altars were made of earth. The birds that flew in the air came to rest upon the earth and it was the final abiding place of all things that lived and grew. The soil was soothing, strengthening, cleansing, and healing.

This is why the old Indian still sits upon the earth instead of propping himself up and away from its life-giving forces. For him, to sit or lie upon the ground is to be able to

think more deeply and to feel more keenly; he can see more clearly into the mysteries of life and come closer in kinship to other lives about him.

The earth was full of sounds which the old-time Indian could hear, sometimes putting his ear to it so as to hear more clearly. The forefathers of the Lakotas had done this for long ages until there had come to them real understanding of earth ways. It was almost as if man were still a part of the earth as he was in the beginning, according to the legend of the tribe. This beautiful story of the genesis of the Lakota people furnished the foundation for the love they bore for earth and all things of the earth. Wherever the Lakota went, he was with Mother Earth. No matter where he roamed by day or slept by night, he was safe with her. This thought comforted and sustained the Lakota and he was eternally filled with gratitude.

From Wakan Tanka there came a great unifying life force that flowed in and through all things – the flowers of the plains, blowing winds, rocks, trees, birds, animals – and was the same force that had been breathed into the first man. Thus all things were kindred and brought together by the same Great Mystery.

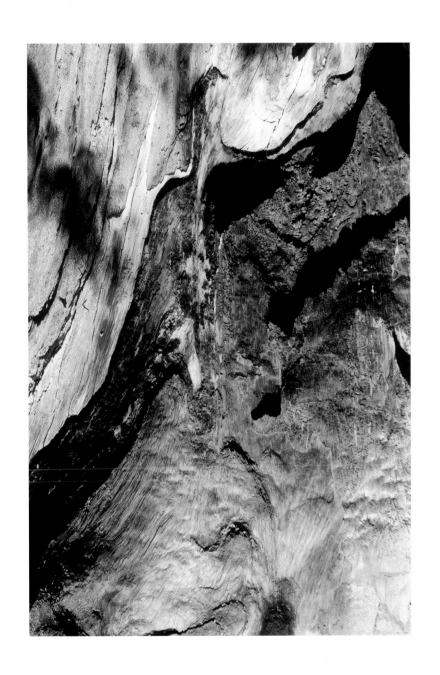

Kinship with all creatures of the earth, sky, and water was a real and active principle. For the animal and bird world there existed a brotherly feeling that kept the Lakota safe among them. And so close did some of the Lakotas come to their feathered and furred friends that in true brotherhood they spoke a common tongue.

The animal had rights – the right of man's protection, the right to live, the right to multiply, the right to freedom, and the right to man's indebtedness – and in recognition of these rights the Lakota never enslaved the animal, and spared all life that was not needed for food and clothing.

This concept of life and its relations was humanizing and gave to the Lakota an abiding love. It filled his being with the joy and mystery of living; it gave him reverence for all life; it made a place for all things in the scheme of existence with equal importance to all. The Lakota could despise no creature, for all were of one blood, made by the same hand, and filled with the essence of the Great Mystery. In spirit the Lakota was humble and meek. 'Blessed are the meek: for they shall inherit the earth,' was true for the Lakota, and from the earth he inherited secrets long since forgotten. His religion was sane, normal, and human.

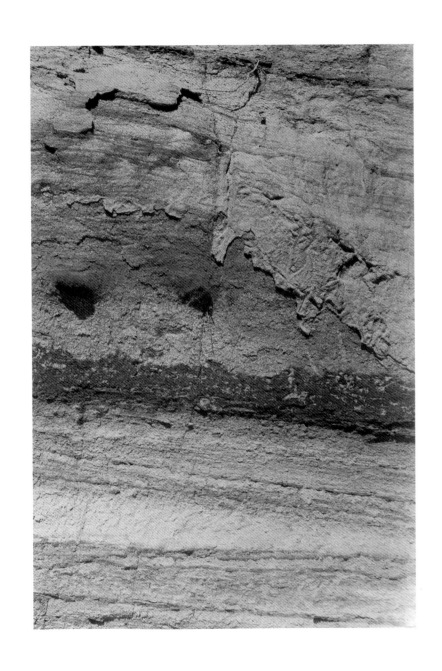

Reflection upon life and its meaning, consideration of its wonders, and observation of the world of creatures, began with childhood. The earth, which was called *Maka*, and the sun, called *Anpetuwi*, represented two functions somewhat analogous to those of male and female. The earth brought forth life, but the warming, enticing rays of the sun coaxed it into being. The earth yielded, the sun engendered.

In talking to children, the old Lakota would place a hand on the ground and explain: 'We sit in the lap of our Mother. From her we, and all other living things, come. We shall soon pass, but the place where we now rest will last forever.' So we, too, learned to sit or lie on the ground and become conscious of life about us in its multitude of forms. Sometimes we boys would sit motionless and watch the swallow, the tiny ants, or perhaps some small animal at its work and ponder on its industry and ingenuity; or we lay on our backs and looked long at the sky and when the stars came out made shapes from the various groups. The morning and evening star always attracted attention, and the Milky Way was a path which was traveled by the ghosts. The old people told us to heed *wa maka skan*, which were the 'moving things of earth.' This meant, of course, the animals

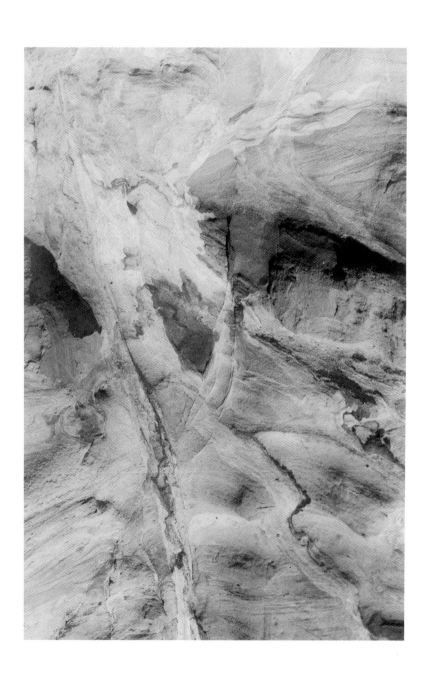

that lived and moved about, and the stories they told of *wa maka skan* increased our interest and delight. The wolf, duck, eagle, hawk, spider, bear, and other creatures, had marvelous powers, and each was useful and helpful to us. Then there were the warriors who lived in the sky and dashed about on their spirited horses during a thunder storm, their lances clashing with the thunder and glittering with the lightning. There was *wiwila*, the living spirit of spring, and the stones that flew like a bird and talked like a man. Everything was possessed of personality, only differing with us in form. Knowledge was inherent in all things. The world was a library and its books were the stones, leaves, grass, brooks, and the birds and animals that shared, alike with us, the storms and blessings of earth. We learned to do what only the student of nature ever learns, and that was to feel beauty. We never railed at the storms, the furious winds, and the biting frosts and snows. To do so intensified human futility, so whatever came we adjusted ourselves, by more effort and energy if necessary, but without complaint. Even the lightning did us no harm, for whenever it came too close, mothers and grandmothers in every tipi put cedar leaves on the coals and their magic kept

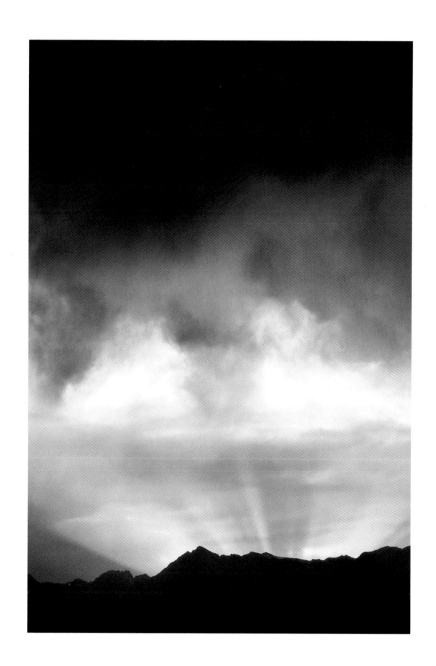

danger away. Bright days and dark days were both expressions of the Great Mystery, and the Indian reveled in being close to the Big Holy. His worship was unalloyed, free from the fears of civilization.

I have come to know that the white mind does not feel toward nature as does the Indian mind, and it is because, I believe, of the difference in childhood instruction. I have often noticed white boys gathered in a city by-street or alley jostling and pushing one another in a foolish manner. They spend much time in this aimless fashion, their natural faculties neither seeing, hearing, nor feeling the varied life that surrounds them. There is about them no awareness, no acuteness, and it is this dullness that gives ugly mannerisms full play; it takes from them natural poise and stimulation. In contrast, Indian boys, who are naturally reared, are alert to their surroundings; their senses are not narrowed to observing only one another, and they cannot spend hours seeing nothing, hearing nothing, and thinking nothing in particular. Observation was certain in its rewards; interest, wonder, admiration grew, and the fact was appreciated that life was more than mere human manifestation; that it was expressed in a multitude of forms. This appreciation

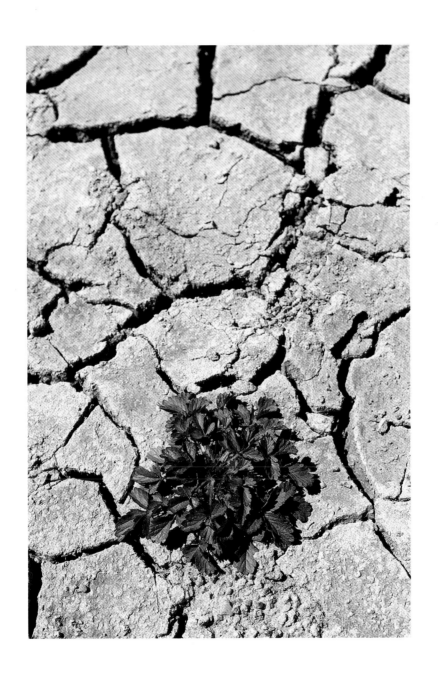

enriched Lakota existence. Life was vivid and pulsing; nothing was casual and commonplace. The Indian lived– lived in every sense of the word – from his first to his last breath.

The character of the Indian's emotion left little room in his heart for antagonism toward his fellow creatures, this attitude giving him what is sometimes referred to as 'the Indian point of view.' Every true student, every lover of nature has 'the Indian point of view,' but there are few such students, for few white men approach nature in the Indian manner. The Indian and the white man sense things differently because the white man has put distance between himself and nature; and assuming a lofty place in the scheme of order of things has lost for him both reverence and understanding. Consequently the white man finds Indian philosophy obscure – wrapped, as he says, in a maze of ideas and symbols which he does not understand. A writer friend, a white man whose knowledge of 'Injuns' is far more profound and sympathetic than the average, once said that he had been privileged, on two occasions, to see the contents of an Indian medicine-man's bag in which were bits of earth, feathers, stones, and various other articles of

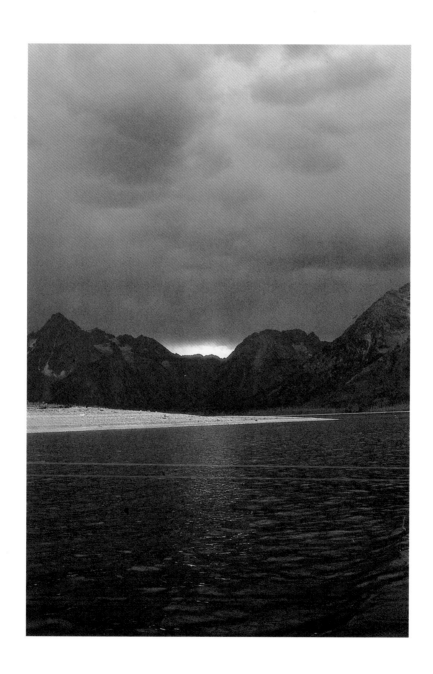

symbolic nature; that a 'collector' showed him one and laughed, but a great and world-famous archeologist showed him the other with admiration and wonder. Many times the Indian is embarrassed and baffled by the white man's allusions to nature in such terms as crude, primitive, wild, rude, untamed, and savage. For the Lakota, mountains, lakes, rivers, springs, valleys, and woods were all finished beauty; winds, rain, snow, sunshine, day, night, and change of season brought interest; birds, insects and animals filled the world with knowledge that defied the discernment of man.

But nothing the Great Mystery placed in the land of the Indian pleased the white man, and nothing escaped his transforming hand. Wherever forests have not been mowed down; wherever the animal is recessed in their quiet protection; wherever the earth is not bereft of four-footed life – that to him is an 'unbroken wilderness.' But since for the Lakota there was no wilderness; since nature was not dangerous but hospitable; not forbidding but friendly, Lakota philosophy was healthy – free from fear and dogmatism. And here I find the great distinction between the faith of the Indian and the white man. Indian faith sought the harmony of man with his surroundings; the

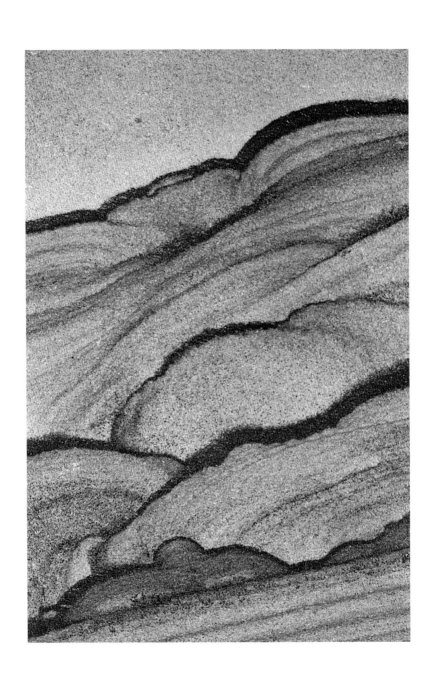

other sought the dominance of surroundings. In sharing, in loving all and everything, one people naturally found a measure of the thing they sought; while, in fearing, the other found need of conquest. For one man the world was full of beauty; for the other it was a place of sin and ugliness to be endured until he went to another world, there to become a creature of wings, half-man and half-bird. Forever one man directed his Mystery to change the world He had made; forever this man pleaded with Him to chastise His wicked ones; and forever he implored his Wakan Tanka to send His light to earth. Small wonder this man could not understand the other.

But the old Lakota was wise. He knew that man's heart, away from nature, becomes hard; he knew that lack of respect for growing, living things soon led to lack of respect for humans too. So he kept his youth close to its softening influence.

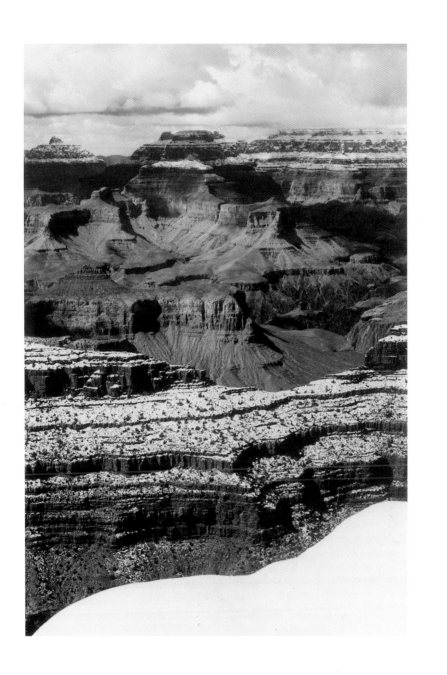

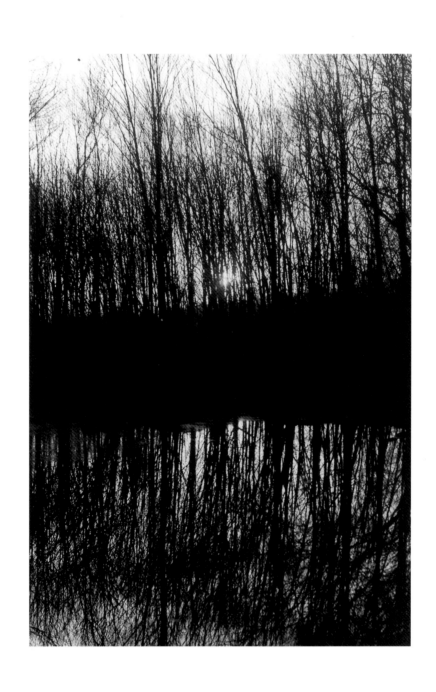

Shooter

All living creatures and all plants derive their life from the sun. If it were not for the sun, there would be darkness and nothing could grow – the earth would be without life. Yet the sun must have the help of the earth. If the sun alone were to act upon animals and plants, the heat would be so great that they would die, but there are clouds that bring rain, and the action of the sun and earth together supply the moisture that is needed for life. The roots of a plant go down, and the deeper they go the more moisture they find. This is according to the laws of nature and is one of the evidences of the wisdom of Wakan Tanka. Plants are sent by Wakan Tanka and come from the ground at his command, the part to be affected by the sun and rain appearing above the ground and the roots pressing downward to find the moisture which is supplied for them. Animals and plants

are taught by Wakan Tanka what they are to do. Wakan Tanka teaches the birds to make nests, yet the nests of all birds are not alike. Wakan Tanka gives them merely the outline. Some make better nests than others. In the same way some animals are satisfied with very rough dwellings, while others make attractive places in which to live. Some animals also take better care of their young than others. The forest is the home of many birds and other animals, and the water is the home of the fish and reptiles. All birds, even those of the same species, are not alike, and it is the same with animals and with human beings. The reason Wakan Tanka does not make two birds, or animals, or human beings exactly alike is because each is placed here by Wakan Tanka to be an independent individuality and to rely on itself. Some animals are made to live in the ground. The stones and the minerals are placed in the ground by Wakan Tanka, some stones being more exposed than others. When a medicine-man says that he talks with the sacred stones, it is because of all the substances in the ground these are the ones which most often appear in dreams and are able to communicate with men.

All animals have not the same disposition. The horse,

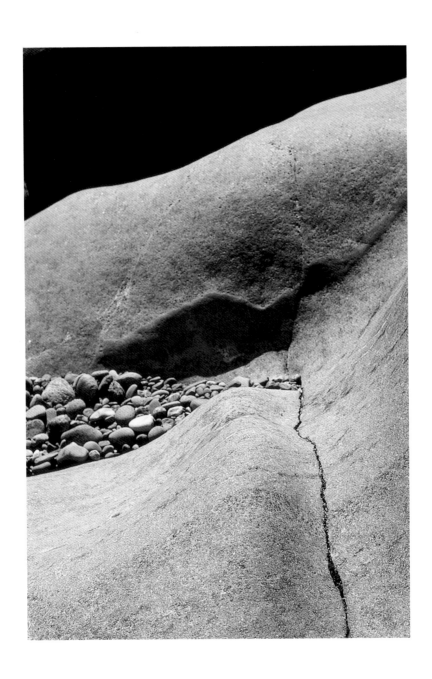

dog, bear, and buffalo all have their own characteristics. This is also true of the fowls of the air, the living creatures in the water, and even the insects, they all have their own ways. Thus a man may enjoy the singing of all birds and yet have a preference for the melodies of certain *kinds* of birds. Or he may like all animals and yet have a favorite among them.

From my boyhood I have observed leaves, trees, and grass, and I have never found two alike. They may have a general likeness, but on examination I have found that they differ slightly. Plants are of different families, each being adapted to growth in a certain locality. It is the same with animals; they are widely scattered, and yet each will be found in the environment to which it is best adapted. It is the same with human beings, there is some place which is best adapted to each. The seeds of the plants are blown about by the wind until they reach the place where they will grow best – where the action of the sun and the presence of moisture are most favorable to them, and there they take root and grow. All living creatures and all plants are a benefit to something. Certain animals fulfill their purpose by definite acts. The crows, buzzards, and flies are somewhat similar in their use, and even the snakes have a

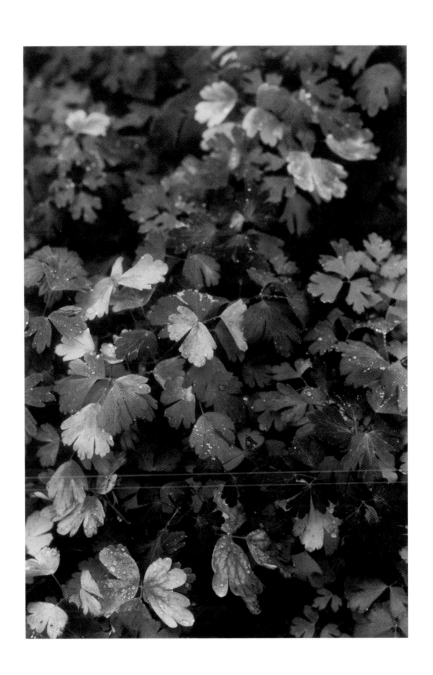

purpose in being. In the early days animals probably roamed over a very wide country until they found their proper place. An animal depends a great deal on the natural conditions around it. If the buffalo were here today, I think they would be different from the buffalo of the old days because all the natural conditions have changed. They would not find the same food nor the same surroundings. We see the change in our ponies. In the old days they could stand great hardship and travel long distances without water. They lived on certain kinds of food and drank pure water. Now our horses require a mixture of food; they have less endurance and must have constant care. It is the same with the Indians; they have less freedom and they fall an easy prey to disease. In the old days they were rugged and healthy, drinking pure water and eating the meat of the buffalo, which had a wide range, not being shut up like cattle of the present day. The water of the Missouri River is not pure, as it used to be, and many of the creeks are no longer good for us to drink.

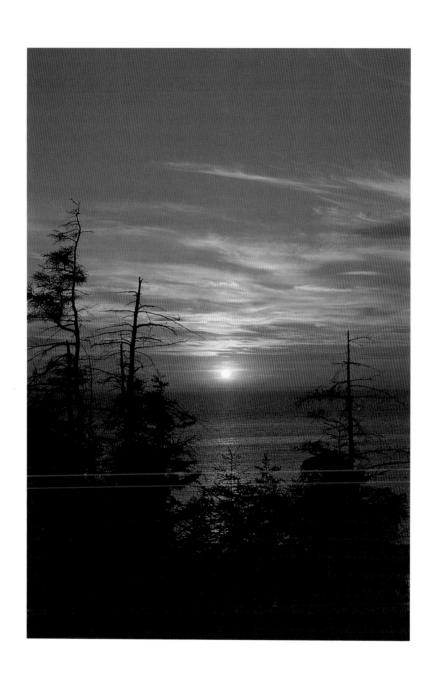

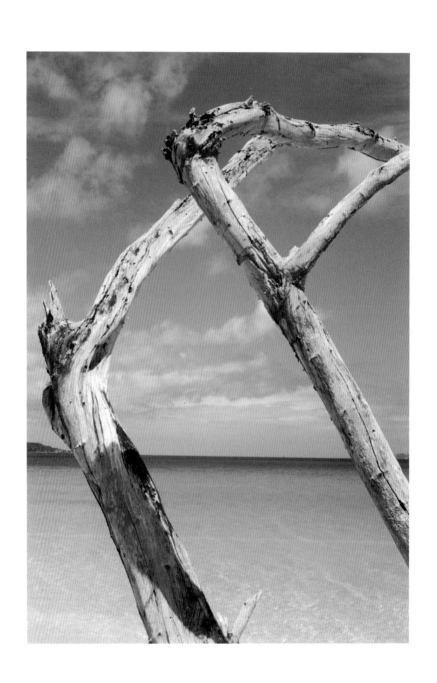

Chased-by-Bears

When a *man* does a piece of work which is admired by all we say it is wonderful; but when we see the changes of day and night, the sun, moon, and stars in the sky, and the changing seasons upon the earth, with their ripening fruits, anyone must realize that it is the work of some one more powerful than man. Greatest of all is the sun, without which we could not live. The birds and the beasts, the trees and the rocks, are the work of some great power. Sometimes men say that they can understand the meaning of the songs of birds. I can believe this is true. They say that they can understand the call and cry of the animals, and I can believe this also is true, for these creatures and man are alike the work of a great power.

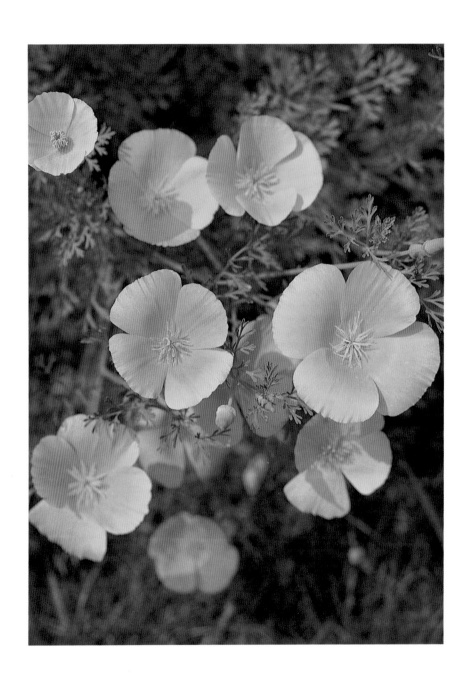

Zitkala-Ša

When the spirit swells my breast I love to roam leisurely among the green hills; or sometimes, sitting on the brink of the murmuring Missouri, I marvel at the great blue overhead. With half-closed eyes I watch the huge cloud shadows in their noiseless play upon the high bluffs opposite me, while into my ear ripple the sweet, soft cadences of the river's song. Folded hands lie in my lap, for the time forgot. My heart and I lie small upon the earth like a grain of throbbing sand. Drifting clouds and tinkling waters, together with the warmth of a genial summer day, bespeak with eloquence the loving Mystery round about us. During the idle while I sat upon the sunny river brink, I grew somewhat, though my response be not so clearly manifest as in the green grass fringing the edge of the high bluff back of me.

At length retracing the uncertain footpath scaling the precipitous embankment, I seek the level lands where grow the wild prairie flowers. And they, the lovely little folk, soothe my soul with their perfumed breath.

Their quaint round faces of varied hue convince the heart which leaps with glad surprise that they, too, are living symbols of omnipotent thought. With a child's eager eye I drink in the myriad star shapes wrought in luxuriant color upon the green. Beautiful is the spiritual essence they embody.

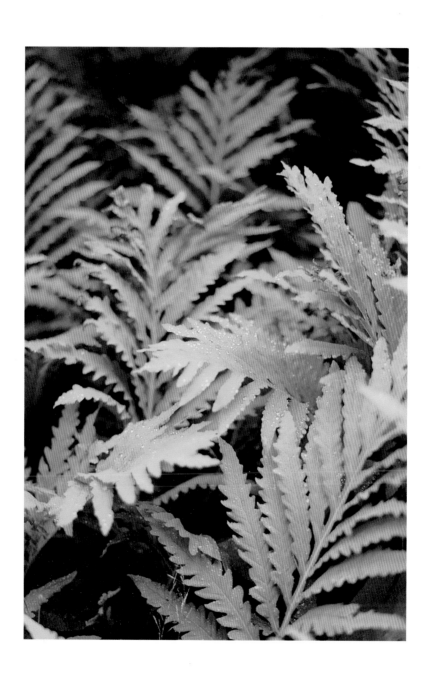

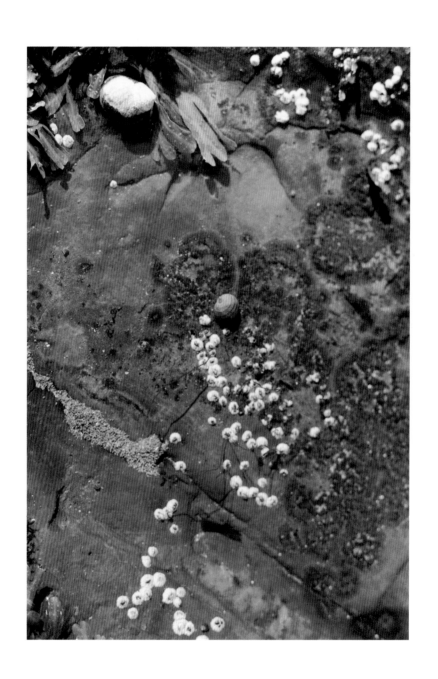

Crowfoot

What is life? It is the flash of a firefly in the night. It is the breath of a buffalo in the wintertime. It is the little shadow which runs across the grass and loses itself in the Sunset.

Seattle

The Great Chief in Washington sends word that he wishes to buy our land. The Great Chief also sends us words of friendship and good will. This is kind of him, since we know he has little need of our friendship in return. But we will consider your offer. For we know that if we do not sell, the white man may come with guns and take our land.

How can you buy or sell the sky, the warmth of the land? The idea is strange to us. If we do not own the freshness of the air and the sparkle of the water, how can you buy them?

Every part of this earth is sacred to my people. Every shining pine needle, every sandy shore, every mist in the dark woods, every clearing, and every humming insect is holy in the memory and experience of my people. The sap which courses through the trees carries the memories of the red man. So, when the Great Chief in Washington sends

41

word that he wishes to buy our land, he ask much of us....

Whatever befalls the earth befalls the sons of the earth. Man did not weave the web of life; he is merely a strand in it. Whatever he does to the web, he does to himself. But we will consider your offer to go to the reservation you have for my people. We will live apart, and in peace....

One thing we know, which the white man may one day discover – our God is the same God. You may think now that you own Him as you wish to own our land: but you cannot. He is the God of man; and his compassion is equal for the red man and the white. This earth is precious to Him and to harm the earth is to heap contempt on its Creator. The whites too shall pass; perhaps sooner than all other tribes. Continue to contaminate your bed, and you will one night suffocate in your own waste.

But in your perishing you will shine brightly, fired by the strength of the God who brought you to this land and for some special purpose gave you dominion over this land and over the red man. That destiny is a mystery to us, for we do not understand when the buffalo are all slaughtered, the wild horses are tamed, and the view of the ripe hills blotted by talking wires. Where is the thicket? Gone. Where is the

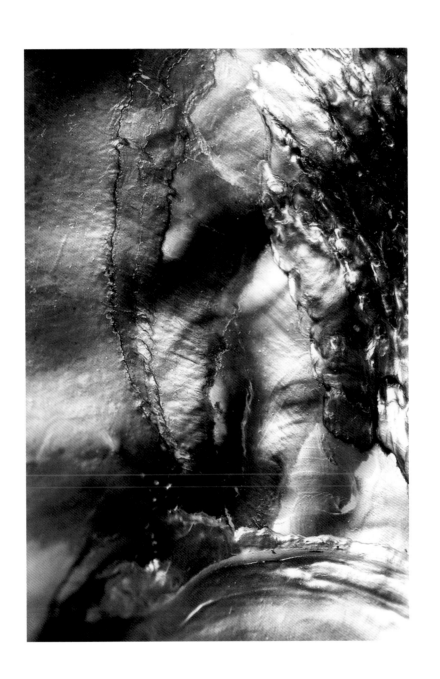

eagle? Gone. And what is it to say goodbye to the swift pony and the hunt? The end of living and the beginning of survival. So we will consider your offer to buy the land.

If we agree, it will be to secure the reservation you have promised. There, perhaps, we may live out our brief days as we wish. When the last red man has vanished from this earth, and his memory is only the shadow of a cloud moving across the prairie, these shores and forests will still hold the spirits of my people. For they love this earth as a new-born loves its mother's heartbeat. So, if we sell our land, love it as we've loved it. Care for it as we've cared for it. Hold in your mind the memory of the land as it is when you take it. And with all your strength, with all your mind, with all your heart, preserve it for your children, and love it….

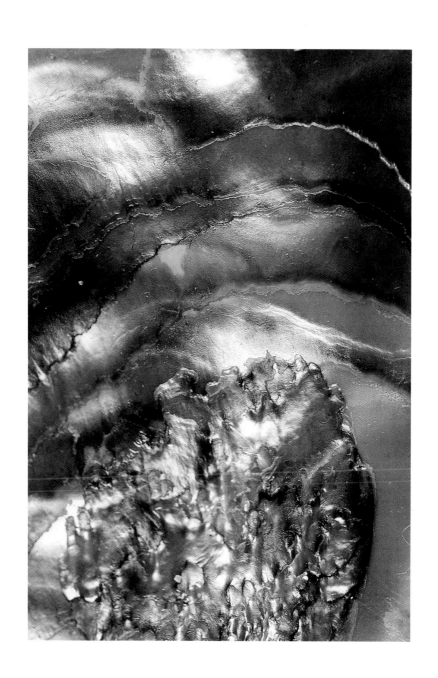

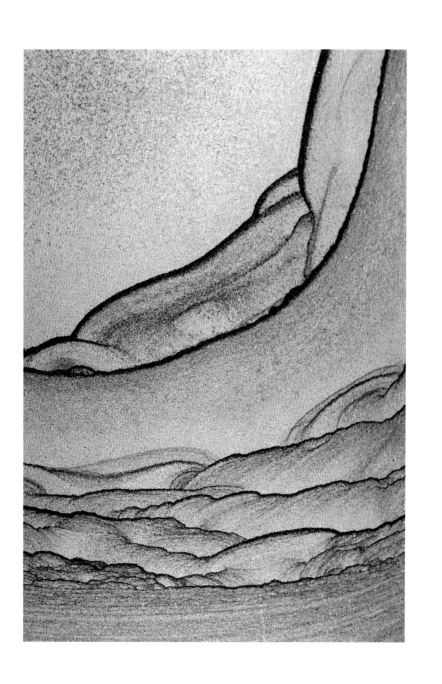

List of Plates

Page ii Split Mountain, Anza-Borrego Desert, California.

 vi Cactus in bloom, Joshua Tree National Monument, California.

 viii Joshua Tree National Monument, California.

 2 Painted Gorge, Anza-Borrego Desert, California.

 4 Flowering yucca, Joshua Tree National Monument, California.

 6 Joshua Tree National Monument, California.

 9 Lightning-scarred sequoia tree, Kings Canyon, California.

 11 Sea cliffs, Del Mar, California.

 13 Sea cliffs, Del Mar, California.

 15 Grand Teton National Park, Wyoming.

 17 Lake bed, Grand Teton National Park, Wyoming.

 19 Jackson Lake, Wyoming.

 21 Sandstone No. 1.

 23 Grand Canyon, Arizona.

 24 Putnam County, New York.

27 Pebbly Beach, Monhegan Island, Maine.

29 Acadia National Park, Maine.

31 Monhegan Island, Maine.

32 Sculptured trees along coast.

34 Poppies, Boothbay Harbor, Maine.

37 Ferns, Monhegan Island, Maine.

38 Tide pool, Bar Harbor, Maine.

40 Evergreen trail, Monhegan Island, Maine.

43 Seashell No. 1.

45 Seashell No. 2.

46 Sandstone No. 2.

Acknowledgments

Brave Buffalo: From *Teton Sioux Music* by Frances Densmore. Bulletin 61, Bureau of American Ethnology, Smithsonian Institution, Washington, D.C., 1918, pp. 207-208.

Chased-by-Bears: From *Teton Sioux Music* by Frances Densmore. Bulletin 61, Bureau of American Ethnology, Smithsonian Institution, Washington, D.C., 1918, p. 96.

Ohiyesa (Charles Alexander Eastman): From *The Soul of the Indian* by Charles Alexander Eastman (Ohiyesa). Paperback edition published by the University of Nebraska Press, Lincoln and London, 1980, pp. 14-15, 46. Copyright 1911 by Charles Alexander Eastman. Originally published by Houghton Mifflin, Boston, 1911.

Shooter: From *Teton Sioux Music* by Frances Densmore. Bulletin 61, Bureau of American Ethnology, Smithsonian Institution, Washington, D.C., 1918, pp. 172-173.